THE FOUR HEATONS
HISTORY TOUR

ABOUT THE AUTHORS

Carole and Phil Page are retired university lecturers and teachers. They have lived permanently in the Heatons since 1990. The inspiration for writing this book came during the long period of lockdown when, with the support of local publication *Moor Magazine*, they produced a series of local history walks aimed at encouraging people to get out and about to explore the rich history of the area in which they live. Phil has written several books for Amberley with his colleague Ian Littlechilds. Carole has written educational texts and short stories and has worked most recently as a freelance Gallery Educator at Manchester Art Gallery.

First published 2024

Amberley Publishing
The Hill, Stroud,
Gloucestershire, GL5 4EP
www.amberley-books.com

Copyright © Phil Page & Carole Page, 2024 Map contains Ordnance Survey data © Crown copyright and database right [2024]

The rights of Phil Page & Carole Page to be identified as the Authors of this work have been asserted in accordance with the Copyrights, Designs and Patents Act 1988.

ISBN 978 1 3981 1638 2 (print)
ISBN 978 1 3981 1639 9 (ebook)

All rights reserved. No part of this book may be reprinted or reproduced or utilised in any form or by any electronic, mechanical or other means, now known or hereafter invented, including photocopying and recording, or in any information storage or retrieval system, without the permission in writing from the Publishers.

British Library Cataloguing in Publication Data.
A catalogue record for this book is available from the British Library.

Origination by Amberley Publishing.
Printed in Great Britain.

INTRODUCTION

The area occupied by the Four Heatons was originally fairly poor agricultural ground located between the north of Stockport and the southern edges of Manchester. The name 'Heaton' is derived from the Anglo-Saxon for a farming enclosure on a heath or high ground.

The four areas we know today started to develop their own identities around the mid-1700s when the building of St Thomas' Church on Manchester Road resulted in the area becoming known as Heaton Chapel. Heaton Mersey developed its own identity with the coming of the bleaching, printing and brickmaking industries in the mid- to late 1800s.

Heaton Moor grew when the building of the railway resulted in the area becoming a popular place to live. Many wealthy Victorians built their houses there, with spectacular views across the Cheshire Plain to the Peak District, Alderley Edge or the Pennines.

Despite the industrial developments in Stockport and Manchester, most of Heaton Norris remained agricultural, although in 1836 twenty mills were employing upwards of 5,000 people.

Apart from the build-up of traffic and the pockets of modern development, the buildings, roads and layout of the area have changed little since the first half of the twentieth century and this book aims to take you on a detailed tour of some of the locations that have defined the character of the Four Heatons over the last 150 years.

KEY

1. West Heaton Bowling, Tennis and Squash Club
2. Priestnall Hey
3. Heaton Mersey Common
4. The Griffin Pub and Thorniley Graves
5. Heaton Mersey Police Station
6. St John's Church and Buildings
7. Station Road
8. Heaton Mersey Bowl
9. Samuel Oldknow's Bleach Works
10. The Bleach Works' Upper Reservoir
11. Park Row Cottages and the Upper Bleach Works
12. Tait's Buildings
13. The Crown Inn and Vale Cottages
14. Heaton Mersey Congregational Church
15. Heaton Mersey Methodist Hall
16. The Edward VIII Letter Box, Fylde Road
17. Fylde Lodge
18. Thornfield Park
19. Heaton Moor Old Library
20. The Old Council Offices
21. Berne Cott, Dunbar and Beech House
22. Heaton Moor Girl Guides' Hall
23. The Savoy Cinema
24. Heaton Moor Electricity Substation
25. Heaton Moor War Memorial
26. No. 31 Parsonage Road
27. Heaton Chapel Reform Club
28. Shaw Road
29. Portland Grove Gentlemen's Club
30. The Plough Inn
31. The Moor Club
32. Heaton Moor Road Shops and Arcades
33. Heaton Moor Park
34. Peel Moat
35. Heaton Chapel Station and Coal Huts
36. St Thomas' Church
37. The Old Toll House
38. The George and Dragon Hotel
39. School Lane
40. The Poco A Poco
41. The Ash Hotel
42. Christ Church
43. The LNER Warehouse, Heaton Norris
44. Bowerfield Open Space
45. The Nursery Inn
46. Green Lane Almshouses
47. Norris Hill Farm

1. WEST HEATON BOWLING, TENNIS AND SQUASH CLUB

The West Heaton Bowling, Tennis and Squash Club was founded in 1873 to meet the demand for sport and recreation opportunities from a growing local community. The club initially offered bowling and croquet, but in 1880 added the popular new activity of lawn tennis. In the 1970s it built the first of its squash courts, responding to the surge in interest in this sport. Today, the club remains true to its original mission to bring sport and recreation to the Heatons, and is still run by volunteers.

2. PRIESTNALL HEY

Priestnall Hey was the home of the Swiss engineer, inventor and industrialist Hans Renold. In 1908 he bought several acres of land in the suburb of Burnage to build his chain manufacturing plant. He believed in forging a strong sense of community in his workforce and the factory site also included facilities for sport and leisure. His home was situated in the grounds but was demolished in the early 1980s. Today the site comprises of a housing estate, a superstore and part of Heaton Mersey Common.

3. HEATON MERSEY COMMON

Today, Heaton Mersey Common is a designated Local Nature Reserve and is home to a variety of wildlife, but beneath the foliage and greenery lies an industrial past. The steep slopes, ravines and ponds were once the site of the quarry and reservoirs for a thriving brickworks industry, owned first by John Thorniley and later developed by Peter Bailey. Bailey's Brickworks, situated on Harwood Road, supplied materials for the boom in housebuilding in the Heatons and finally closed in the 1960s.

4. THE GRIFFIN PUB AND THORNILEY GRAVES

The Griffin, a traditional Victorian pub with many original features, was built by John Thorniley in 1831 and acquired by Joseph Holt in 1921. Opposite the pub was the home of the Thorniley family, Grundy Hill House, now a row of modern houses. A fenced-off area reveals the graves of Isaac and Hannah Thorniley, ancestors of John Thorniley, who chose to be buried in the grounds of their home. A board by the graves provides further information.

5. HEATON MERSEY POLICE STATION

As the Heatons' population grew, so did the need for a resident police force. The police houses built by Lancashire County Constabulary included a purpose-built police station with cells at the back and housing for two policemen and their families. Wrongdoers would often have to be held in custody locally until being sent for trial in Manchester, but in 1913 responsibility for policing transferred to Stockport and the cells were no longer needed. The houses were used by serving policemen until 1961 but are now privately owned.

6. ST JOHN'S CHURCH AND BUILDINGS

The church was consecrated in 1850 and boasted a spire of 125 feet surrounded by pinnacles. A severe storm in 1894 caused serious damage when a pinnacle crashed through the roof, and a century later the spire was deemed unsafe and finally removed. The church has a rare circular churchyard and, as you progress clockwise around it, you will see the original rectory and then the schoolmaster's house, both now private dwellings; the school buildings, now home to Stella Maris School; and the well-used community hall. The war memorial was erected sometime after 1922 but the exact date is unknown.

7. STATION ROAD

Station Road was the entrance to Heaton Mersey station. Apart from the station, it contained the Methodist Church 'Tin Chapel', which was constructed from corrugated metal materials, and the imposing Heaton Mersey Sunday School. The station closed in 1963 and was buried beneath landfill to prepare for a new housing estate. The Methodist Chapel was demolished when a new church was built on the corner of Didsbury Road and Cavendish Road in 1906. The Sunday school opened in 1805 and was regularly attended by over 200 children. It was demolished in 1967.

8. HEATON MERSEY BOWL

Heaton Mersey Bowl is formed as the land drops away from the ridge of Didsbury Road – where the prosperous Victorian middle classes built their substantial houses looking out over the Cheshire Plain – to the industrial banks of the River Mersey. It is an open green space that has continuously served its community. In the past it has offered gardens, allotments and areas for bleached cloth to be pegged out in the sun and rain and, in current times, space for sport, dog walking and increasingly rare opportunities for sledging on its steep sides.

9. SAMUEL OLDKNOW'S BLEACH WORKS

The early Industrial Revolution required water power to operate the machinery in many of the new factories. Rural sites were attractive to mill owners as there was often a plentiful supply of water to support processes such as bleaching, printing and dyeing. These natural advantages led Samuel Oldknow to open his first factory on the banks of the Mersey, at the end of Vale Road, in 1785. The building of these extensive works transformed Heaton Mersey from a small, rural, agricultural community to a substantial industrial village. The factory provided finishing processes for cotton fabrics, which were spun and woven at nearby textile mills.

10. THE BLEACH WORKS' UPPER RESERVOIR

Both the Upper Bleach Works and the Lower Bleach Works needed a plentiful supply of water to facilitate the processes used in bleaching and rinsing cotton fabrics. Ordnance Survey maps of the time show that there were four reservoirs on land to the east of the Lower Bleach Works and two large reservoirs near the railway bridge on Vale Road feeding the Upper Bleach Works. One of these reservoirs (now a fishing pond) is still there today, a short climb from the cobbled roadway at the end of Vale Road to the north of Craig Road.

11. PARK ROW COTTAGES AND THE UPPER BLEACH WORKS

Behind Park Row Cottages (which were built for workers by Samuel Stocks on land owned by Robert Parker) stood Heaton Mersey Upper Bleach Works. The success of Samuel Oldknow's riverside mill was such that he went on to purchase a second plot of land nearer to Didsbury Road where more cottage-based work took place. By the 1880s about half the adult workforce in Heaton Mersey was employed at the two sites. Around 1860, the main site was eventually bought by two Manchester businessmen, F. Melland and E. Coward. Under their ownership, the business survived until it was closed in 1992.

12. TAIT'S BUILDINGS

Tait's Buildings were two rows of back-to-back houses built by Mortimer Lavater Tait who managed the Lower Bleach Works in the mid-1880s. They were built in 1850 using the bricks of a demolished factory chimney and were constructed by cutting away a steep slope behind the cottages in Vale Road. The grim buildings were known locally as Barrack's Yard and provided accommodation for his younger workers, including those who came from orphanages and workhouses. Most of the buildings were demolished in the 1970s and the land now houses Tait Mews.

13. THE CROWN INN AND VALE COTTAGES

The Crown forms part of a group of buildings that were originally a tiny hamlet beside Parrs Fold and Vale Road, which, together with the hamlet of Grundy Hill, just to the west, were the core of what later became Heaton Mersey Village. It is possible that The Crown emerged to serve local drovers or stockmen who would rest their animals overnight at Parrs Fold as they drove their horses and carts along Didsbury Road, which formed part of the old saltway from Manchester to Northwich.

MERSEY ROAD

14. HEATON MERSEY CONGREGATIONAL CHURCH

The main church building was opened in 1840 to house a growing congregation. It was then extended, with schoolrooms built to the side for the Sunday school. In 1988 the church was found to have dry rot and was demolished, with flats and a car park being built in its place. Worship moved to the upper hall of the remaining church buildings to the side in 1990. The grave of Cephas Linney, a local coal merchant, can be found in what is left of the original churchyard.

15. HEATON MERSEY METHODIST HALL

Throughout the First World War the volume of casualties meant that existing hospitals could not cope with the numbers of men being returned from the front, so temporary Red Cross hospitals were set up to support the medical services. The Heatons had two such hospitals: situated in the Reform Club, on Heaton Moor Road, and in the Methodist Church Hall, on Cavendish Road. They were organised by the local committee of the Red Cross and an ex-teacher named Walter Brownsword, who, although too old to enlist, was keen to help with the war effort.

16. THE EDWARD VIII LETTER BOX, FYLDE ROAD

At the corner of Fylde Road and Mauldeth Road in Heaton Mersey is a rare example of an Edward VIII letter box. Edward VIII became king on the death of his father, George V, on 20 January 1936 and abdicated on 11 December 1936, ending a reign of only 327 days. Only about 160 letter boxes bearing Edward VIII's insignia were made and fewer still survive, as many were replaced or modified.

17. FYLDE LODGE

The School, situated on the corner of Priestnall Road and Mauldeth Road, was originally a private house but became a school in 1893. It was run by the Misses Sales and was primarily an establishment for the daughters of local well-to-do families. The school was highly successful and was taken over by Stockport LEA in 1921, eventually becoming the all-girls grammar school for the local area. In 1966, the school moved to new premises on Priestnall Road, which after further educational reorganisation became Priestnall School.

18. THORNFIELD PARK

Thornfield Park was the last park to be developed in the area by Heaton Norris Urban District Council, in 1913. The park had a bowling green, which reflected the popularity of the sport at the time. The green is still in use and the park boasts a new, brick-built pavilion to replace what had been one of the oldest surviving park buildings. It was unfortunately destroyed in 1996.

19. HEATON MOOR OLD LIBRARY

Originally a family home, Moor House was bought by Stockport Council in 1950 to provide temporary premises for the Lending Library. It had a separate 'Juvenile Section' on the first floor offering books for younger readers – the first library in Stockport to do so, although children had to be aged thirteen to become members. The library did not move to its current location, at the side of the old District Council Offices, until 1992 when Moor House became a private home once again.

20. THE OLD COUNCIL OFFICES

The large and imposing building has stood on Thornfield Road since 1901. Originally built as the council's district offices, it has served various purposes over the years including as the location for Heaton Mersey Infants School, which occupied the site up until the early 1970s. The earliest documented use of the building relates to the meetings of the Heaton Norris Urban District Council, which were convened on the third Thursday of each month at 7 p.m. The chairman was Sir Thomas Thornhill Shann JP, who rose to become the mayor of Manchester between 1903 and 1905.

21. BERNE COTT, DUNBAR AND BEECH HOUSE

The buildings around Moor Top have changed little since the area was called Owler Nook. Tradespeople and shoppers mingle together much as they have done on this spot for over 100 years. On the opposite side to the older shops stood three large buildings: Berne Cot, Dunbar and Beech House. Berne Cot was built in Colonial style by its owner who had returned to Heaton Moor after service in the Bengal Lancers. Beech House was demolished in the 1970s to make way for a new supermarket, but the upper storeys of Berne Cot and Dunbar can still be seen above the modern shop frontages.

22. HEATON MOOR GIRL GUIDES' HALL

The Guide Association was formed in 1909 due to the efforts of the many girls who refused to be excluded from the lively, outdoor, practical activities offered to Boy Scouts. By 1917 Heaton Moor had a thriving Girl Guides group and, nationally, such girls were making an important contribution to the First World War effort. The group met in the former Unitarian Church, a red-brick listed building on Kings Drive. The church itself closed in 1910 and became the Girl Guides' Hall where Girl Guides continue to meet today.

KING'S DRIVE

23. THE SAVOY CINEMA

The Savoy was opened by the mayor of Stockport in March 1923. It had a balcony and seated over a thousand people. Audiences flocked to see its first screening, a silent production of *The Virgin Queen* starring Lady Diana Manners, with accompanying music from Constance Cross's Ladies Orchestra. It was adapted for sound in 1930 and, with the coming of the Second World War, it provided much-needed light entertainment and screened regular newsreels from the conflict in Europe. It was also occasionally used as an evacuation centre for local families whose homes were under threat of bomb damage.

24. HEATON MOOR ELECTRICITY SUBSTATION

This Grade II listed electricity substation was built in around 1902 for Manchester Corporation. The imposing red-brick and sandstone frontage is designed in Edwardian baroque style to complement and blend in with the affluent character of the neighbourhood. The central entrance doors are topped by a pediment bearing the arms of Manchester Corporation. It provides a rare early example of this type of structure, designed to bring electricity to a growing suburb, while at the same time demonstrating a sense of civic pride and local identity in its construction.

25. HEATON MOOR WAR MEMORIAL

The memorial was commissioned to commemorate those servicemen from Heaton Moor and Heaton Chapel killed in the First World War. It was designed by Manchester sculptor John Cassidy, who created the bronze memorial of a soldier on a stone pedestal at an estimated cost of around £2,000 (around £112,000 in today's money). The memorial was completed and unveiled in January 1921 and contains the name of Gertrude Mary Powicke, believed to be the only woman commemorated on any memorial in the borough of Stockport.

26. NO. 31 PARSONAGE ROAD

Until the mid-nineteenth century, the area around Heaton Moor was largely agricultural land used for crops, livestock and peat cutting. The construction of Heaton Chapel station in 1852 was to change all that as the wealthy middle classes moved out of the city in search of land and fresh air. No. 31 Parsonage Road typifies this shift. It is a Grade II listed former farmhouse, surrounded by later nineteenth-century housing development. The buildings form an L-shape with the house gable (end-on to the road) and an attached barn. Although modernised and glazed, it is possible to see the flat-headed cart entry to the barn, along with brick vents. All the buildings are now converted to residential use.

27. HEATON CHAPEL REFORM CLUB

Heaton Chapel Reform Club was finished in 1886. It was designed by Alfred Darbyshire who also worked on the plans for Manchester Town Hall. It was used to provide accommodation for 'Liberal Gentlemen' and glamorous social events were held there. Inside was a large billiards room and the internal décor consisted of marble fireplaces, moulded timber dado rails, plaster cornices and heavy wooden-panelled doors. The club was often visited by Prime Minister David Lloyd George, but was forced to close in 2008, with its 100 members moving down Heaton Moor Road to the Conservative Club. Today the building is used for private residences.

28. SHAW ROAD

Shaw Road once led down to Shaw Fold Farm, which spread across the land now occupied by the Buckingham Road housing estate. Its most interesting building stands on the corner of Heaton Moor Road. No. 112 has been home to banks, lavish tearooms, high-class drapers and firms of solicitors. A carving on the side contains a grasshopper, the liver bird, and two sheaves of corn, possibly a reflection on the semi-rural nature of the Heatons. No. 26 Shaw Road is the former home of Cecil Kimber, managing director of the famous MG Motor Company. A blue plaque in his memory is located at the front of the house.

29. PORTLAND GROVE GENTLEMEN'S CLUB

Portland Road Gentlemen's Club was typical of the type of male recreational establishments that were popular in well-to-do residential areas in Victorian and Edwardian times. The club took over these premises at the end of 1886 when the previous tenants, Heaton Moor Reform Club, moved into their purpose-built premises on Heaton Moor Road. The club lasted until after the First World War, but had disappeared by 1924. After this time the buildings were converted into shops including a laundrette, a shoe repair shop and an antiques shop. The building was turned back into housing in 1995.

HEATON
MOOR
MEN'S CLUB

30. THE PLOUGH INN

The Plough was built in 1886 and has a distinctive exterior that incorporates carved stone inscriptions and scenes. It is primarily built of red sandstone and red brick in a Jacobean style with an Arts and Crafts influence. The frieze above the window reads, 'A Merrie Heart Goes All Ye Day Your Sad Tires In A Mile.' The entrance to the right has a carved panel above the doorway showing a ploughman in medieval dress with his team. Above the arched doorway is an inscription: 'He That By The Plough Would Thrive Himself Must Either Hold Or Drive.'

31. THE MOOR CLUB

The Moor Club was originally called Heaton Moor Conservative Club. It was built in 1881 and came into being because of the demand for recreational facilities created by an increase in population following the building of Heaton Chapel station. Club facilities included a snooker hall, two bars, a boardroom and a dining suite. The club was further extended in 1883 to include a reading room on the ground floor and a Masonic hall on the upper floor. The club became the Moor Club in 2008 after merging with the nearby Liberal Reform Club.

THE
MOOR
CLUB

AD 1881

32. HEATON MOOR ROAD SHOPS AND ARCADES

The coming of the railway in 1852 enabled the development of Heaton Moor as a thriving and desirable new suburb, and one of the earliest thoroughfares, Heaton Moor Road, characterised the strong sense of local identity that is still evident today. Substantial brick villas were set well back from the leafy, tree-lined road, providing a sense of space and greenery. Churches, shops, public houses and other amenities were built alongside in similar architectural style and the Victorian parade of shops with its canopy and cast-iron columns is locally listed.

33. HEATON MOOR PARK

The development of Heaton Moor Park emerged from the social and cultural concerns of the Victorian age. The Victorian ideal of preserving open spaces through the development of public parks had gathered pace throughout the country during the second half of the nineteenth century. Baron Wilbraham Egerton of Tatton was the benefactor of Heaton Moor Park and he donated approximately 4 acres of land to Heaton Norris Council in 1894. When the park was opened on 17 July 1897 the occasion was linked with a royal event, Queen Victoria's diamond jubilee.

34. PEEL MOAT

Peel Moat is the oldest historical site in the Heatons. At first glance it is an inauspicious piece of ground: a raised earthwork, perfectly square, surrounded by a waterlogged ditch, teeming with wildlife and vegetation. A low causeway leads you onto the earthwork and here the conundrum begins: what exactly was this site used for? Was it a moated, medieval defensive site, a pele tower, or something much older? One theory is that it might have been a Roman signal station heading south out of the city from the large Roman garrison at Castlefield.

35. HEATON CHAPEL STATION AND COAL HUTS

In the mid-nineteenth century, a local clergyman, Edward Jackson of St Thomas's Church, realised that one of his former pupils at Manchester Grammar School was the superintendent of the northern division of the LNWR. Determined to put Heaton Chapel on the map, he used his influence to instigate the building of a new station on the railway line heading south from Manchester. The opening of the station turned the surrounding area into a desirable commuter belt for those working in Manchester and Stockport. The wooden huts opposite, which were refurbished in 2021, originally housed F. S. Trueman's Coal Offices.

36. ST THOMAS' CHURCH

The Four Heatons we know today started to develop their own identities around the mid-1700s when the building of St Thomas' Church on Manchester Road resulted in the area becoming known as Heaton Chapel. The land was donated by a local yeoman named Thomas Collier, and the church was built in 1755 and consecrated in 1765. The new building was first used as a chapel of ease, acting simply as an outpost for local churches, but after seventy years St Thomas' was assigned its own parish, making it at the time the parish church for the entire Heatons.

37. THE OLD TOLL HOUSE

Manchester Road was the original main road from Stockport to Manchester and ran through Heaton Chapel. A tollgate was built opposite St Thomas' Church when the road became a turnpike road in the early 1720s, but all vehicles had free access after 1873. The road is thought to be of Roman origin, part of the route that ran from Manchester and entered Stockport down Lancashire Hill. The tollbooth stood proudly at the junction opposite St Thomas' School right up until the 1960s when it was demolished in a road traffic accident.

38. THE GEORGE AND DRAGON HOTEL

In 1824 the building located on this site was a farm, which was eventually turned into a coaching inn. The pub originally advertised 'good stabling' reflecting the importance of its location on the main thoroughfare. It was first rebuilt in 1909, losing its distinctive balcony and moving slightly further away from the road. More recently it used to have a full-size snooker table, but this disappeared during recent modernisation. It originally served ale from Clarke's Reddish Brewery, which, despite its name, operated from premises on Sandy Lane, Heaton Norris. It survived until 1963 when it was taken over by Boddingtons.

39. SCHOOL LANE

The southern corner of the junction was once the location of a school run by the Hollinpriest Charity. The organisation was prevalent in the area around the late 1700s and early 1800s. School Lane takes its name from the charity and the school existed for a further 100 years up until the beginning of the twentieth century. In its later years, it was known as Travis's School after its headmaster, William Travis. William was quite a local character and presided over the school for fifty years. When he died, a memorial to commemorate his life was erected in St Thomas' Church.

40. THE POCO A POCO

The club opened as the Empress Cinema on 6 May 1939. It was the last cinema to be built in Stockport for many years, given the forthcoming war and the years of austerity that followed. During the early 1960s its main attraction was as a bingo club, but after being badly damaged by a fire in 1967 it reopened a year later as the Poco A Poco Nightclub and Casino, and hosted a series of events featuring some of the biggest names in show business. Today the Hind's Head pub sits on the site in Empress Drive.

41. THE ASH HOTEL

The Ash Hotel was built by Wilson's Brewery in 1901 on ground that was previously occupied by pleasure gardens. It was designed to be one of their landmark public houses, built in Jacobean manor style complete with a bowling green and billiards room. It survived as a public house up until the early 1990s, but then lay unused until it was converted into the Ash Tea Rooms in April 2011. These eventually closed in 2019 and a planning application to turn it and the land into a location for residential dwellings was granted.

42. CHRIST CHURCH

Christ Church was designed by Manchester architect William Hayley, and completed by 1846. The church was in use up to the 1970s, but around this time it was discovered that the fabric of the building was in very poor condition, including a considerable amount of dry rot. In 1977 the church caught fire. By the time the fire could be tackled, considerable damage had been done to the structure and the fate of the building was all but sealed. The tower, spire, and parts of the adjoining walls remain today, but the five clock bells, made by Warner in 1896, were stolen in 1977.

43. THE LNER WAREHOUSE, HEATON NORRIS

The present building was constructed in 1877 for the London & North Western Railway and replaced a smaller storage building on the site, which was destroyed by fire. The LNWR building was in full use by 1882, primarily for the cotton trade to cater for the ever-growing demand in Stockport. The warehouse narrowly escaped destruction from a bomb in the Second World War, sustaining slight damage to the north-west corner of the building.

44. BOWERFIELD OPEN SPACE

Bowerfield Open Space is situated off Bowerfold Lane and has fine views across Stockport and its railway viaduct. The area was once called Bowerhouse Fold and partly incorporated Bent House Farm, which was owned by the Melling family. There was a toll route between Wellington Road and Green Lane across the Mellings' land, providing the family with extra income. The farm closed during the 1950s and the land was sold and developed into a residential area, retaining the open space for recreational use.

45. THE NURSERY INN

The Nursery Inn (Grade II* listed) was built in 1939 for Hydes Brewery, replacing a nineteenth-century public house on roughly the same site. Its name is thought to have been derived from a plant nursery that occupied the land to the rear in the previous century. The bowling club to the rear was established in 1917 and the public house also acted as the first headquarters of Stockport County Association Football Club. Heaton Norris Rovers established a ground behind The Nursery for the 1888–89 season. They changed their name to Stockport County the following year.

46. GREEN LANE ALMSHOUSES

James Ainsworth of Heaton Norris left provision in his will for these twelve semi-detached cottages, with gardens and a stone entrance archway, to be built on Green Lane in 1907. James was a wealthy local businessman who wished to provide accommodation for some of the neediest and most deserving residents of the Heatons. The bequest in his will stated that they were to be allocated to old people 'whose honourable record and needy circumstances make such shelter and assistance in their declining years well-deserved'. The first residents moved in around 1907.

47. NORRIS HILL FARM

The farm had been owned by the Hancock family since 1888. A stroll along Green Lane would take you to the unmade road that gained access to the farm. The farm consisted of a house, hay barn, stables and a pig sty. There was always a scattering of hens and ducks pecking around the yard, and you could buy milk from the farm, which was delivered locally by horse and cart. It stood on 14 acres of land, which stretched from the southern side of Green Lane down to Didsbury Road.

ACKNOWLEDGEMENTS

Thanks to Stockport Heritage Library for permission to use a small number of photographs that first appeared in *The Four Heatons Through Time* (Amberley, 2014). We would also like to acknowledge the following publications, which were an invaluable source of information when researching some of the facts to go with the photographs: Jones, Elizabeth, *Old Heatonians* (Stockport Libraries, 1997); Heaton Mersey Research Group, *Heaton Mersey: A Victorian Village 1851–1881* (Stockport Historical Society, 1985); Rowbotham, Phil, *Heritage Walk Series*, Editions 5, 6 and 9 (Stockport Heritage Trust), Heaton Moor Conservation Character Appraisal, March 2006 (Stockport Council). Thank you to Gerald England for permission to use his photograph of the Edward VIII letterbox.

This book was compiled with the support of *Moor Magazine*, the magazine for the Four Heatons. Thanks to Steve Howarth, Sharon Byrne and Melissa Marriot, who encouraged us to bring our original walks to a wider audience and continue to support the sharing of historical knowledge across the Four Heatons.